Ron Mueck

RON MUECK

Susanna Greeves and Colin Wiggins

National Gallery Company, London
Distributed by Yale University Press

This book was published to accompany
an exhibition at the National Gallery, London
19 March – 22 June 2003

A version of the exhibition also appeared at:

Museum of Contemporary Art, Sydney
December – March 2003
Presented in association with the 2003 Sydney Festival

De Hallen (Frans Hals Museum), Haarlem
November – January 2004

Contents

Foreword

The National Gallery holds works made before the end of the nineteenth century, and the hyper-real and emphatically twenty-first century sculptures of Ron Mueck perhaps seem surprising in such a context. A sculptor who works with modern materials, including silicone and fibreglass, and whose background is in the special-effects industry for the world of movies and advertising, might seem to have little in common with, say, Rembrandt and Raphael.

Mueck's debut as an exhibiting artist came at the *Sensation* exhibition at the Royal Academy in 1997, where his *Dead Dad* was first seen. The astonishment caused by this small sculpture was in inverse proportion to its diminished scale. Yet a work that looked so new, raw and shocking can, of course, also be understood as being located firmly in the Western tradition of the *memento mori*, a poignant reminder of our own mortality.

On accepting the invitation to become the fifth National Gallery Associate Artist, Mueck found himself drawn to another subject that is addressed repeatedly in the Gallery's collection, the mother and child. Mueck's meditations on birth and motherhood provide a modern foil for those many great works from the past that deal with that same theme.

Thanks are due to Anthony d'Offay and Laura Ricketts, the artist's agents, for their invaluable help during the period of Ron Mueck's appointment. Thanks also to Susanna Greeves, who has known the artist from the beginning of his career as a sculptor, and in her essay ably places his work into a historical context. Principal thanks, of course, are due to Ron Mueck himself for demonstrating so convincingly that the traditional subjects from the art of the past are capable of radical re-interpretation.

Charles Saumarez Smith
Director of the National Gallery, London

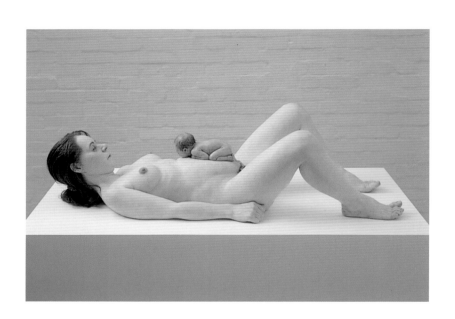

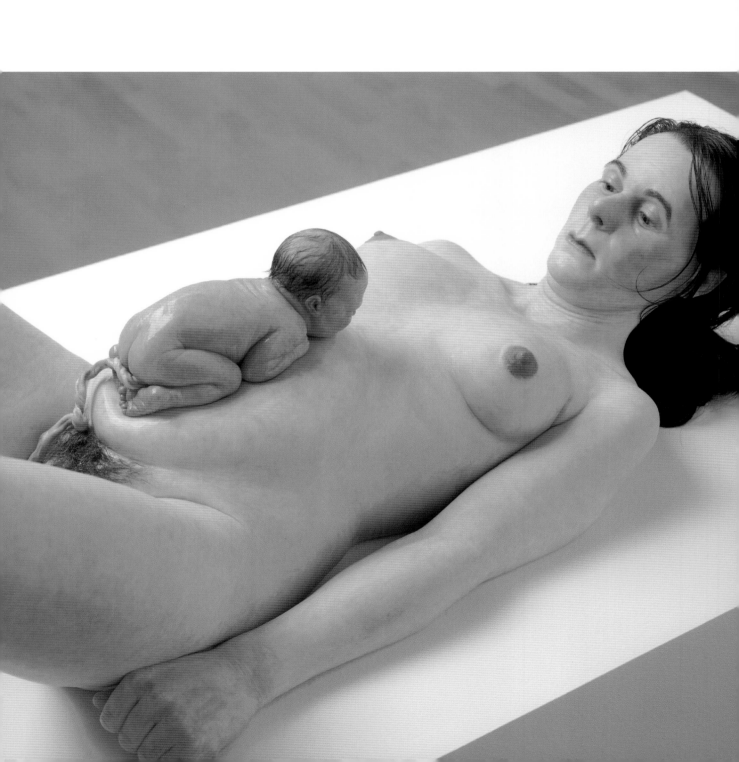

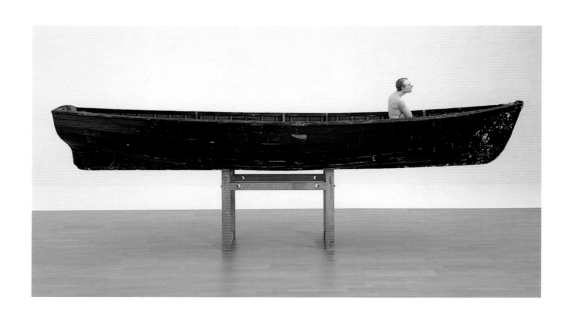

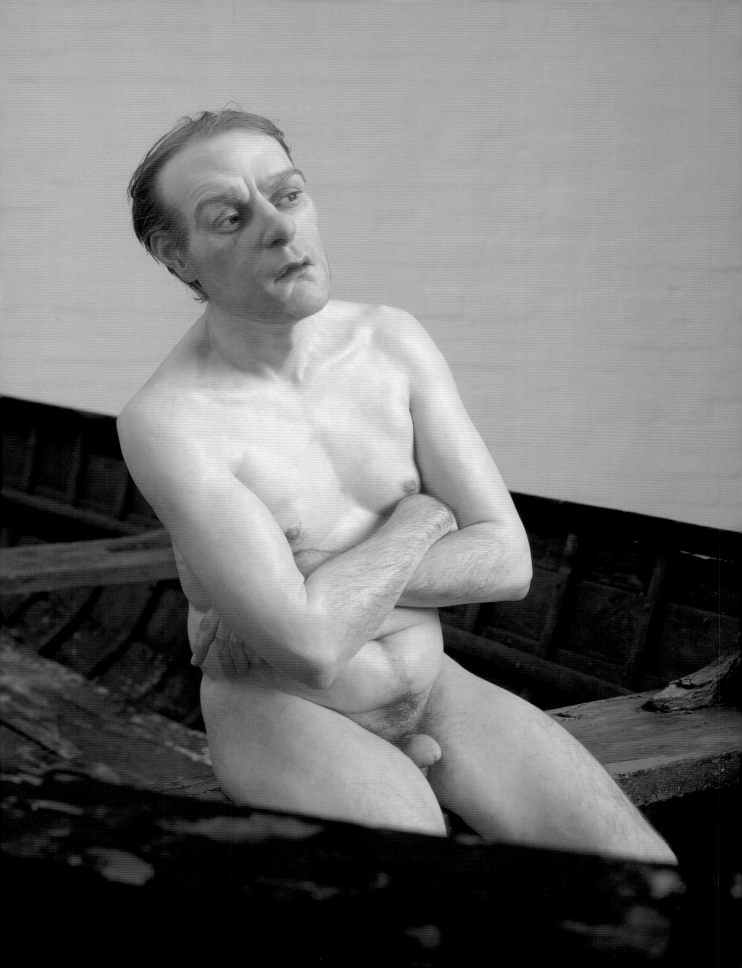

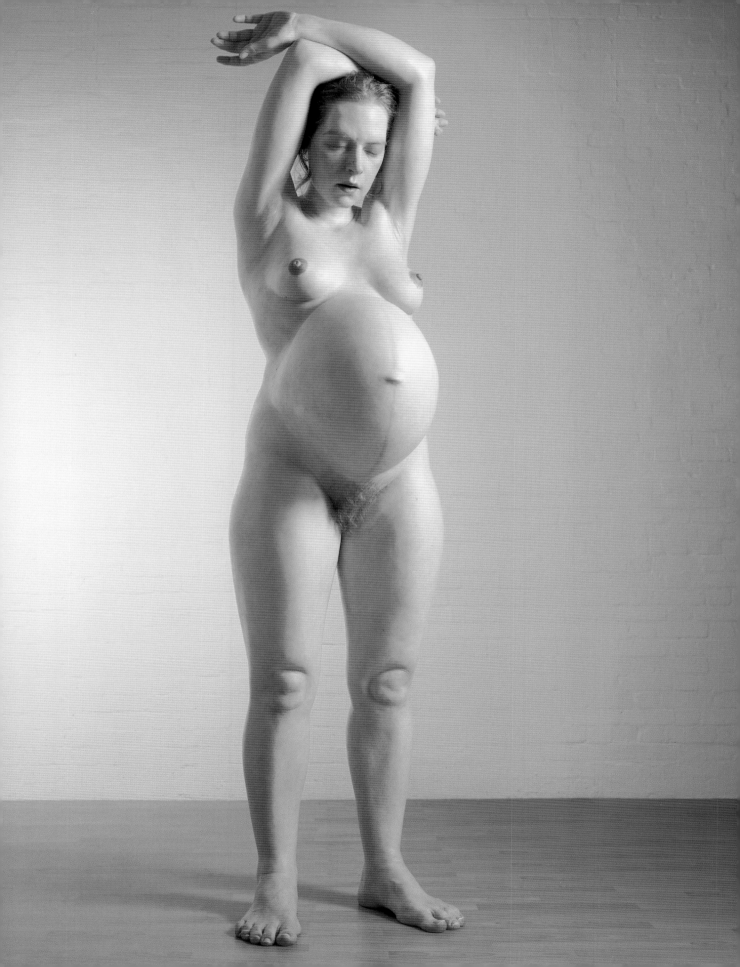

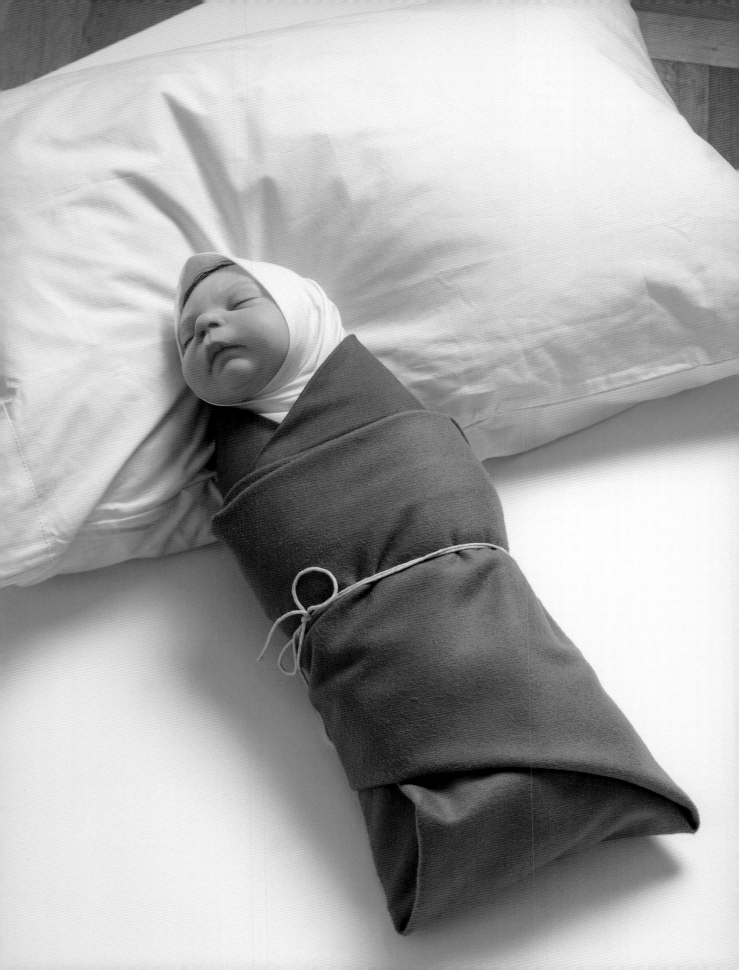

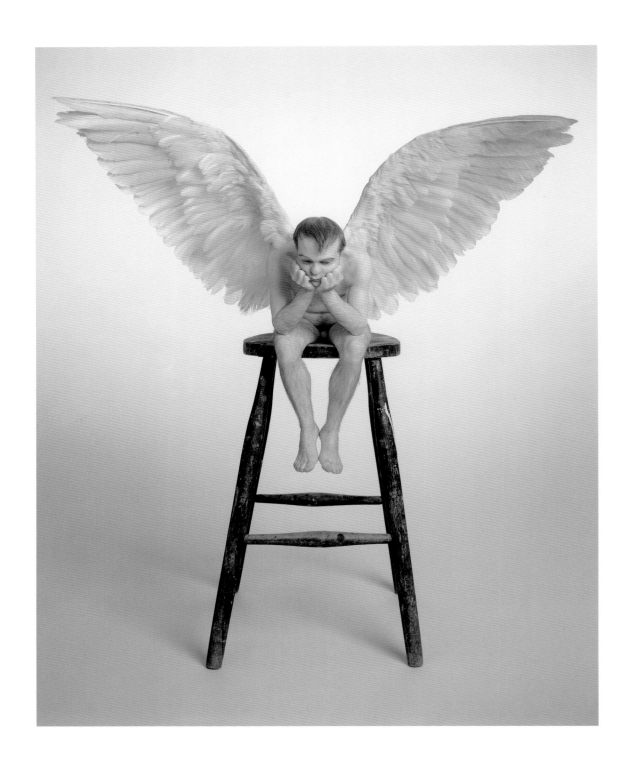

Angel, 1997
Mixed media
102 × 85 × 63 cm
The Saatchi Collection, London

Ron Mueck at the National Gallery

Ron Mueck's *Angel*, made in 1997, is a small naked figure with an impressive pair of feathered wings. Seated on a stool, he strikes a thoughtful and slightly melancholy pose. The scale of the figure is less incongruous than other Mueck sculptures, as it is perhaps easier to accept the apparent miniaturisation of a figure purporting to come from another world. As with Mueck's other pieces, however, there is still the compulsion to examine the figure's surface as closely as possible, to scrutinise every detail. The wings are made of goose feathers and are utterly convincing: if angels do exist, it might not be a surprise to find they look like this.

Angel has an unexpected source: Giovanni Battista Tiepolo's *Allegory with Venus and Time* from the National Gallery (overleaf). Tiepolo's representation of Time inspired Mueck to make his own winged character. Other subjects Mueck addressed in the late 1990s include self-portraiture, birth and ageing: all timeless and traditional themes. These links between Mueck's work and the art of the past prompted the National Gallery to approach him to become its fifth Associate Artist.

There was another significant reason for the invitation, namely the high standards of craftsmanship that Mueck demands of himself. Craftsmanship and skill dominate the history of Western art right up until the Modernist revolution that started in the last part of the nineteenth century. Since then, the acquisition and use of manual skills has been downgraded in terms of artistic status, while at the same time the idea, or concept, has advanced. From the deliberate crudities of Cubist collage onwards, there have been few significant movements in the twentieth century that have required a high level of technical skill. The great exceptions were the remarkable German artists of the Neue Sachlichkeit such as Otto Dix, Georg Grosz or Christian Schad, who emerged in the 1920s and whose intense and hyper-real paintings owed a deep debt to their German predecessor, Albrecht Dürer. Mueck similarly

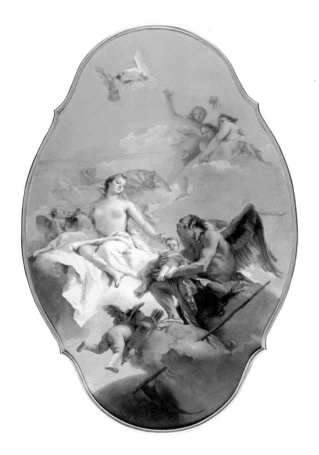

has German roots. His mother and father were both German, and emigrated to Australia before Mueck was born. The language of his childhood home was German. Comparison of Mueck's *Dead Dad* (page 45) with *The Painter's Father* (page 53), attributed to Dürer, is instructive. The surface detail in both works is focused upon minutiae, the textures of ageing. Both share an exact and obsessive observation, as the stubble pushes its way through the skin.

Mueck's experience in the special-effects industry has given him a highly accomplished range of skills. Only rarely will he employ professional technicians to help produce his sculpture, preferring to work alone. This reluctance to employ assistants perhaps indicates that he is dealing with subjects that are too private and personal to entrust to another pair of hands. Occasionally Mueck will use an assistant for those jobs where there are no creative choices to be made. An assistant might, for example, be entrusted with repetitive tasks such as making the individual hairs or producing the textures for goose-flesh, but only Mueck can make decisions about how the work will look. Occasionally, should he make a second version of a piece, he will allow an assistant to help him with the casting and to complete some of the more tedious processes, such as filling a mould with layers of silicone. Even then, he will insist on closely supervising every stage.

The reasons are clear. For Mueck, the making of the piece is a crucial part

Giovanni Battista Tiepolo (1696–1770)
An Allegory with Venus and Time,
about 1754–8
Oil on canvas
292 × 190.4 cm
The National Gallery, London

of its meaning. He seems to feel a psychological bond with the pieces he makes, to forge an intimate relationship that excludes any third party. The artist's reluctance, refusal even, to discuss these issues – which he considers of no concern to anyone else – is itself of interest.

Mueck's process is relatively conventional. Initial ideas are tested with small plaster maquettes, and the final piece begins with a sculpture made of clay. For the smaller works, this is supported with a wire armature of exactly the same type that Degas, for example, used for his wax sculptures. For the bigger pieces, the clay sculpture is supported by a large assemblage of scaffolding that is covered with chicken wire and then wrapped in layers of scrim soaked in wet plaster. When the clay sculpt is complete, he takes a mould from it and then casts it out in silicone or fibreglass, to which he has already added colour. Aside from his choice of material for the final piece, this method is exactly the same as that of Donatello, Rodin or the ancient Greeks when casting in bronze.

Although this sounds simple there are always risks. Mueck's work is dependent on absolute perfection for its effect. The slightest trace of a seam or any other technical blemish would ruin the illusion and the piece would lose its power. Mueck's sculptures have been compared to waxworks, but close examination of a waxwork will always reveal the piece for what it is: the surface always appears dead. Mueck's works draw spectators towards them, enticing viewers to examine as closely as possible every pore and anatomical detail with a kind of gruesome fascination, as if they

Lorenzo Costa (about 1459/60–1535)
with Gianfranceso Maineri (active 1489–1506)
*The Virgin and Child Enthroned
(La Pala Strozzi)*, probably 1499
Oil and tempera on wood
247 × 163.8 cm
The National Gallery, London

are trying to catch the artist out. But they never do — and the uncanny lifelike quality of Mueck's sculptures leaves the possibility, lurking in the back of one's mind, that some other, sinister, process has been employed in their creation.

Mueck moved into his National Gallery studio in August 1999. The brief for the Associate Artist is to make work in response to the National Gallery's collection. Aware of the danger of pastiche, Mueck was reluctant to force links or to make literal transcriptions of National Gallery paintings. At the beginning of his tenure he carried on working as if he had not moved into the National Gallery at all, expressing the hope that the collection would influence him subliminally. During his first months in the studio he produced much of the work for his second solo show at the Anthony d'Offay Gallery, held in 2000. *Man in Raincoat*, *Big Man*, *Mask I* and the little wall-mounted *Baby* (see cover) were all made in the National Gallery. As he approached the end of his period of appointment Mueck expressed disappointment that more explicit links had not developed. However, despite the artist's reservations, the themes that he has dealt with do connect powerfully with the Gallery's collection. Indeed, he cites the wall-mounted babies as the first pieces that he made consciously influenced by his time in the National Gallery. He was particularly struck by an early sixteenth-century altarpiece by Lorenzo Costa and Gianfrancesco Maineri in which the Christ Child seems to stand almost completely unsupported by his mother, as confident, independent and aware as any adult. Something of the same spirit inhabits Mueck's babies. They seem so tiny and frail, yet they convince us that they can feel and think for themselves.

Mother and Child

The first piece Mueck made specifically for his exhibition at the National Gallery was *Mother and Child*, which can be seen as a logical complement to *Dead Dad* (page 45). The mother is similar in scale to the earlier work but is alive, playing her role at the start of life, rather than its end. It is Mueck's only piece to date to show more than a single figure, and thereby implies a relationship, albeit one that has hardly had time to form. Mueck has made previous sculptures of babies on a larger-than-life scale, so his return to the subject is not a complete surprise, whereas his frank and unprecedented approach to a traditional subject certainly is.

The National Gallery has many paintings that show the mother and child theme, most prolifically, of course, in the guise of the Virgin Mary with the infant Christ. Mueck has looked carefully at many of these. A favourite is the

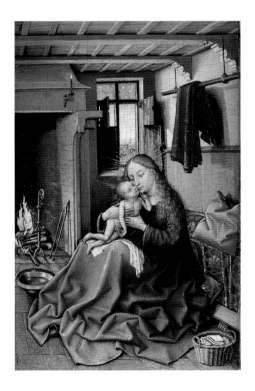

Virgin and Child in an Interior from the workshop of Robert Campin. The tiny size of the painting and the curious way in which the relationship between the mother and child is depicted proved to be of great interest to Mueck. In common with many Renaissance and later representations of the Virgin and Child the infant Christ is shown as a highly unrealistic baby. Mueck was intrigued at how 'un-babylike' the infant Christ often seems.

Before the invention of photography there were obvious reasons why artists did not have easy access to a newborn child, or even images of one. Consequently they often took their visual cues from other

Workshop of Robert Campin
The Virgin and Child in an Interior, about 1435
Oil on oak
18.7 × 11.6 cm
The National Gallery, London

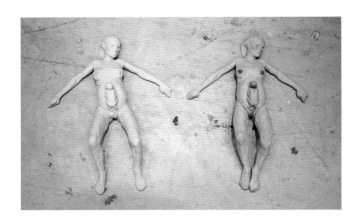 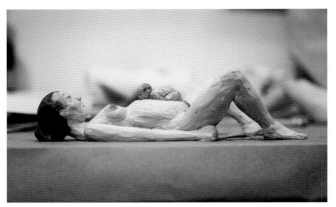

artworks rather than from life. Furthermore, artists were always under pressure
to conform to time-honoured and sanctified patterns, conscious that they were
not simply representing an ordinary baby.

When Mary and the newborn Christ Child are depicted, the two characters
are usually shown as having already formed a bond: either the conventional
mother-and-child relationship of mutual affection and care, or a demonstration
of religious devotion. Mueck's sculpture shows the mother-child bond being
formed in front of our eyes: the child arrived just seconds ago. It glistens
with mucus, the umbilical cord is still attached, the mother's stomach has not
yet begun to contract. The mother remains in the birthing pose, with legs
splayed and knees up. Her body is still tense after the pains of her labour. She
seems unsure about what to do with her hands and looks down at the child
with an expression verging on the blankness of shock. This child is hers, of
her flesh, but the love that she knows she should feel has not yet had time to
manifest itself.

Although this sculpture adds to a long tradition, Mueck has chosen a
moment that, significantly, has always been avoided in Christian art. By treating
an instant of utmost privacy – before any emotional tie has been formed –
and displaying it for our scrutiny, the artist seems to be inviting us to pry. Some
will feel uneasy about having such unrestricted access to this woman's body

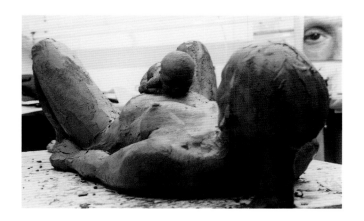 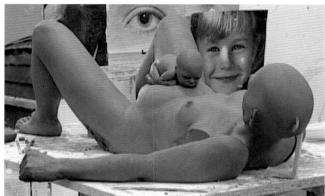

as they succumb to the temptation of focusing more and more upon those parts of her that we are used to understanding as private. However, the scale, at approximately half life-size, effectively keeps us at a safe psychological distance from the couple. We can look at her safe in the knowledge that she will not return our gaze, that she cannot see us. The miniaturisation gives the sculpture an intense and precise hyper-reality: it is akin to studying something through the wrong end of a telescope. The scale reminds us that she is, after all and despite appearances, only a sculpture.

The mother is not a portrait of any specific person but an imaginary type. Mueck did, on occasion, work with a model while making the piece but only because he felt the need for direct observation of details such as hands and feet. His other principle sources were photographic, particularly medical textbooks. The baby squints through almost-closed eyelids, open just enough for it to view for the first time the person responsible for its entry into the world. Curiously, the baby has a distinct personality and seems to have emerged of its own volition, crawling instinctively and unaided to its present position. The implication is that this birth was unattended by any outside parties: doctor, midwife or partner. The child already has a free will, an independence that casts the act of leaving its mother's womb as the first stage of a journey that will inevitably end with the child leaving its mother as adulthood is attained.

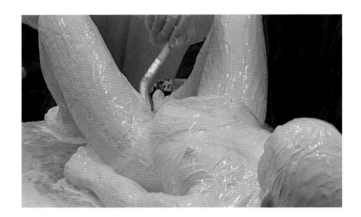
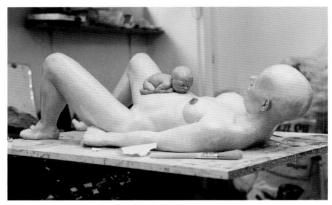

Mueck never disputes that his work has autobiographical content. He was present at the birth of his two daughters, and it seems inevitable that he drew upon these experiences, profound yet commonplace, when making this piece. Technically and typically for Mueck, it is a *tour de force*. The mother and child were cast separately, both in fibreglass. Fibreglass is hard and has the physical advantage over silicone that any seams still visible after the casting process can be filed away. However, its rigidity does not allow the insertion of individual hairs, which must be glued on to the surface. As Mueck's sculptures invite such close inspection this gave him a problem, because glued-on eyebrows and eyelashes can never look completely authentic. This was not an issue with the pubic hair, which could be glued on safely because the sticky mess of the afterbirth acts as camouflage, but it was a challenge for the mother's head.

To resolve this difficulty, Mueck cast out another face from the original mould, this time using silicone. Silicone's rubber-like quality enabled the artist to punch the individual hairs in, one by one, making them look as if they are actually growing through the skin. Mueck then removed the original fibreglass face and replaced it with the new silicone one. He was careful to cut along a crease in the mother's neck and consequently affixed the new face invisibly. For Mueck, technical problems like these become creative problems. The decision to embark upon a particular sculpture, and then the actual making of

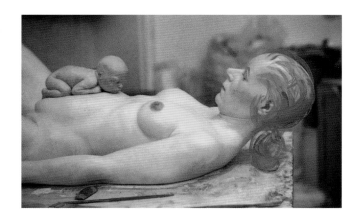 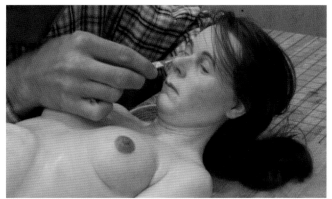

it, are not two processes: the concept and the making are inseparable. Each new sculpture presents the artist with another set of problems, often unforeseen. By solving these problems successfully, the artist cements his emotional bond with the sculpture.

Man in a Boat

The *Man in a Boat* consists of a naked man, just over half life-size, seated facing forward in a rowing boat. It is the only piece in the exhibition that does not deal explicitly with the theme of birth and motherhood. However, seen in the context of the other pieces Mueck has made for the show it happily takes a place as a metaphorical representation of birth. The Virgin Mary has long been described as the vessel through which Christ came to the world and the ship, or *navis institoris*, is a traditional symbol of the Immaculate Conception. Mueck was unaware of this when he started work on the piece, and expressed both delight and amusement when he learned that one of his favourite National Gallery paintings, *The Immaculate Conception* by Diego Velázquez, which is unambiguously about birth, includes a tiny representation of a ship, set among an array of other symbols, at the bottom of the picture.

Mueck did not consciously choose the subject as a birth metaphor: he even

doubts that the theme of his National Gallery exhibition should be construed as 'birth', preferring instead the idea of containment. The infant in the womb, the *Swaddled Baby* and the man in the boat all share a physical limitation on their movement that both restricts and protects.

Mueck bought the boat, which was lying derelict, from a group of Sea Cadets. He was initially motivated by the necessity of producing a long and narrow sculpture to fill a particular space for a proposed exhibition in New York. While trawling through old sketches looking for ideas, Mueck chanced upon an old drawing of a man in a boat and so the idea was born. As it turned out, the piece was not finished in time for the New York show.

The figure is made from silicone, a choice of material dictated by Mueck's desire to give him body hair. Accordingly, the artist's principal technical difficulty was to cast the sculpture with no visible seams because with silicone, unlike fibreglass, these cannot be filed away. Mueck made the mould so as to minimise the exposed seams, but even then he could not avoid having one join where the sides of the mould come together and where, had the casting not been successful, a seam would have been very evident, ruining the piece. An initial casting was a failure, and Mueck was forced to make another mould from the original clay. Further trial castings proved problematic, but the final piece came out of the mould with no seam evident. Mueck claims that this was more by luck than judgement because the pieces of the mould always expand in unpredictable

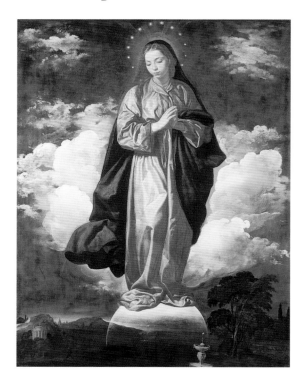

Diego Velázquez (1599–1660)
The Immaculate Conception, about 1618
Oil on canvas
135 × 101.6 cm
The National Gallery, London

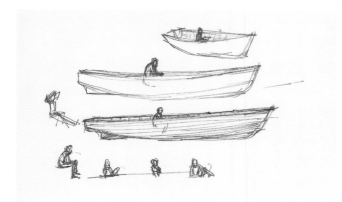

places while drying, and the abutting edges are almost impossible to keep in precise register.

Removing the finished piece from the mould is not an easy process, as silicone is easily stretched out of position or torn, which would render several weeks' work wasted, and it was a moment of high tension when the successful cast was extracted. Without wishing to stretch a point, it is not unlike witnessing a birth. Liquid soap is used to lubricate the limbs, which are half encouraged and half forced to slither out, accompanied by alarming squelching and popping sounds. In its finished and displayed state the figure is supported on a metal armature because silicone will not support itself. Consequently, when the figure emerged, he was dripping with the green slime of the soap and flopping about like a fish on dry land. The time, effort and emotion invested in making the piece heightened the final moment of triumph for the artist.

The scale of the figure, relative to the viewer and to the boat itself, puts one in mind of Gulliver, and it is also hard not to think of Pinocchio – another allegorical traveller – and of the strange paternal relationship between the craftsman and his finished product. Mueck laughs at and derides such ideas, perhaps rightly. He does not deny though, the element of self-portraiture present in this work. The initial clay sculpture was made using his own body as a reference. He examined closely his hands and his feet and incorporated them

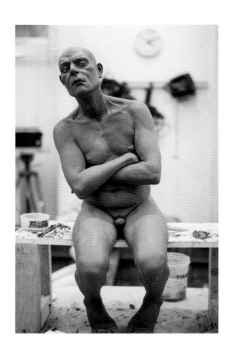 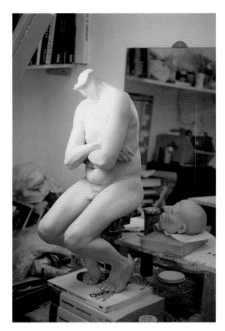 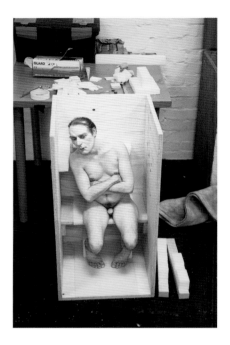

into his work. He looked at the texture of his own skin and tried to find ways of making an accurate impression of it. In the past he has used his own face to work from, most notably in the over life-size self-portrait *Mask*. While the *Man in a Boat* looks nothing like the artist, it can still be understood as having aspects of self-portraiture.

By placing the figure in a vessel, the sculpture immediately gains a narrative aspect. Mueck's earlier single figure sculptures are in static poses, either passive or quietly introspective. This figure however, has his neck slightly stretched and his quizzical expression indicates a curiosity about what lies ahead. The movement is subtle but it is there, none the less, and gives the figure an outward-looking aspect unseen in Mueck's previous work. Mueck suggests that this might be because, while working in the National Gallery, he was in daily contact with a range of different people who would visit his studio and discuss the work in progress, whereas his usual practice is to work in isolation.

The understated nature of *Man in a Boat*'s animation owes something to the failure of a previous piece, a small sculpture of an old woman with wide-open

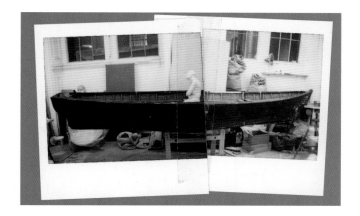 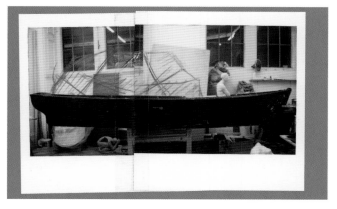

eyes and a broad smile. Despite being executed to Mueck's customary high standards, he rejected this figure. Although it functioned perfectly as a technical exercise, Mueck felt that it communicated no sense of the mystery or psychology that is so important in his work. The artist concluded that his mistake was an attempt to make a sculpture that freezes an active pose, rather than one that implies the potential for activity. Consequently, the neck movement of the *Man* is so slight as to be almost unnoticeable.

Part of making the piece involved deciding exactly where in the boat the figure should sit and which way he should face. Each new position opened up different possibilities: is he travelling towards somewhere, or leaving something behind? Is he in control of his own destiny or at the whim of chance? Does he worry about his fate or is he indifferent to it? The boat has no means of propulsion, so the implication is that he is has no control over either his destiny or destination. However, placing him boldly at the front suggests he is travelling forwards and is curious, which adds to the implications of the slightly craning neck. Mueck originally intended that the *Man* should face backwards and be seated in the centre of the boat, but when he was placed in the centre, the vessel seemed to lose its sense of impetus, appearing becalmed or drifting slowly. This position did make the formal links with the *Mother and Child* more apparent, however. Both works represent small figures perched on top of much

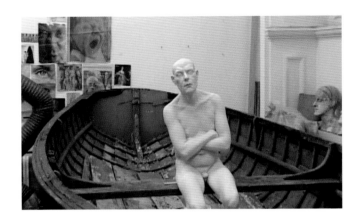
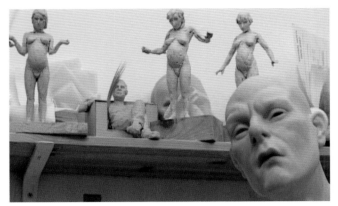

larger recumbent forms that can be understood as taking them on an unpredictable journey.

Another earlier idea was to place a tarpaulin behind the figure, covering an arrangement of unseen packages. Viewers would know then that he had taken something with him from his past life that might be of use in the future. This idea was only rejected at a relatively late stage, and Mueck decided to allow the figure in the boat to have nothing. Despite the vulnerability of his nakedness the little man seems safe enough, for now at least. The boat provides a protective cocoon around him. But all journeys must come to an end and the *Man* will one day be no longer protected, forced to face the world to which the boat delivers him. Once again, the metaphor of birth suggests itself.

Pregnant Woman

Mueck intends his *Pregnant Woman* to be approached from behind. Only by investigating the work further, by walking around it, should the viewer be able to discover the woman's pregnancy. From behind, she is simply an over-sized woman with stocky proportions, holding her arms above her head. Despite being made from unyielding fibreglass, she looks fleshy and soft. The pose,

with her arms above her head, makes her appear to be resting, contemplative, caught in a private moment. As with all of Mueck's pieces the surface detail is noticeable even from a distance, but the temptation to come in close is irresistible. Veins, moles and areas of goose-flesh become visible, all executed with the artitst's customary uncompromising exactitude. The feet and hands are especially impressive.

As we move around the sculpture, her massive protuberance is revealed. This hugely swelling belly, with the skin stretched to breaking point, invades the spectators' space and is of sufficient proportion to indicate that the child within is nearing the end of its term. Mueck makes us visualise the position of the child's head and limbs, as it curls up in foetal safety – before it bursts out to arrive in the world.

Mueck started work on *Pregnant Woman* in his usual way, by making a series of small plaster maquettes around fifteen centimetres tall. They all take up the same four-square pose, with the arms of each one in a different position. These maquettes were an investigation into the range of possibilities for the pose. At this stage, no decision about the scale of the finished piece had been taken. After these pieces he embarked upon a larger maquette, this time of clay, with which he finalised the position of the arms. Mueck decided to give her closed eyes after he saw an exhausted-looking pregnant woman in the National Gallery café resting with her eyes shut.

The final clay sculpture was made on an assemblage of scaffolding that had been covered in chicken wire to indicate the form of the woman. On top of this he applied layers of scrim soaked in wet plaster and, once these had dried, the clay was built up over the frame. When the clay sculpture was finished, a mould was taken from it and the final piece cast in fibreglass. Mueck then cast a separate face in silicone and attached it in the same way as he had done for *Mother and Child*.

While making *Pregnant Woman*, Mueck made his most extensive use of models in his career so far. He worked with one particular woman for a

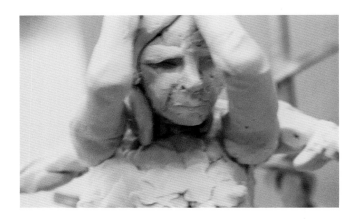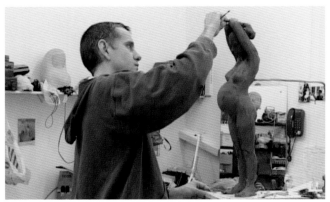

period of nearly three months, starting when she was six-months pregnant. Nevertheless, despite her crucial input, the piece is in no sense a portrait. Mueck found himself choosing different parts of different models in exactly the same way that the Classical Greek painter Zeuxis was reputed to have done. He also used photographic sources and even looked at himself in a mirror when he was having particular difficulty with the position of the arms

The finished piece is two-and-a-half metres tall. Mueck is reluctant to state reasons for his choice of scale, but once he had decided to make the woman larger-than-life, there was still the important issue of exactly how much bigger it should be. To resolve this, he made three large drawings of the woman in profile, each slightly different in height. These were then attached to a wooden scaffold and taken by the artist into the room in the National Gallery where the sculpture would be shown, so that he could see them in relation to the surrounding space and choose the size of his *Pregnant Woman* accordingly. Although Mueck wanted to make a large sculpture, he was anxious that the finished piece should not impress by magnitude alone. To this end he needed to keep her size human enough that viewers could still relate to her as a fellow creature – not merely perceive her as an outsize freak.

Comparisons with *Mother and Child* are worth making. What would the effect have been if Mueck had made the earlier piece on a larger-than-life scale

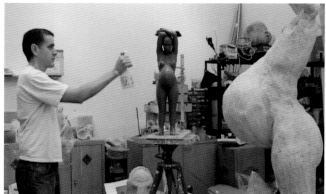

and made *Pregnant Woman* smaller? *Mother and Child* shows a woman with her baby at a moment of absolute extremity and utter vulnerability. The diminished scale poignantly intensifies these ideas. A greater size would therefore mean sacrificing those aspects of the work that make it so convincing. Conversely, although *Pregnant Woman*'s maquette (which is now destroyed) still worked beautifully, it did not have the same degree of emotive suggestion as *Mother and Child*. The exaggerated size of *Pregnant Woman* forcefully communicates the weight borne in the woman's womb. We are forced to wonder at the physicality and burden of child-bearing, and the sculpture becomes a tribute to motherhood.

Enlarging the figure adds another powerful aspect. As she looms above us she gains a totemic quality, and becomes a great Earth Mother at whose feet we stand. Her enlarged scale psychologically diminishes spectators, giving us the relative scale of a child. We are made to feel subordinate before the powerful form before us: motherhood personified, the origin of life. Mueck has made an Earth Goddess for the twenty-first century who takes her place with representations of ancient fertility godesses, or the prehistoric female stones of Avebury or the Boyne Valley. And yet she is still profoundly human. Her body has the imperfections of reality. The closed eyes allow us to feel unobserved as we look at her. They also encourage us to imagine her thoughts and her

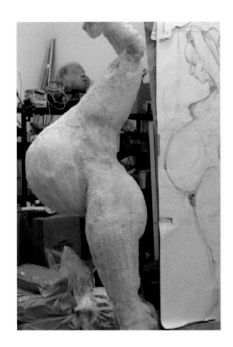 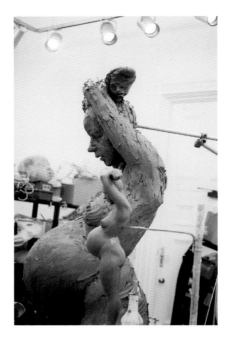 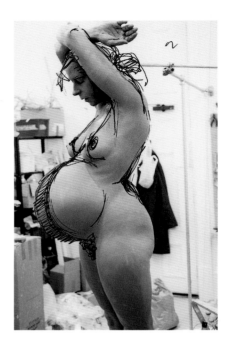

feelings. She looks exhausted, careworn and individual, weighed down both literally and metaphorically.

There is no specific National Gallery source. As with *Mother and Child*, she stands in relation to a tradition rather than to a particular painting. She originates from Mueck's desire to carry on his investigations into the mother-and-child theme. Historically, there are representations of the obviously pregnant Virgin Mary but these are rare and the National Gallery owns none. However, Mueck's sculpture does act as a reminder of how often in litanies to the Virgin Mary, she is referred to as a holy vessel or container. Spectators would surely be justified in seeing Mueck's sculpture as a modern Mary, pondering deeply the implications of what she carries within her.

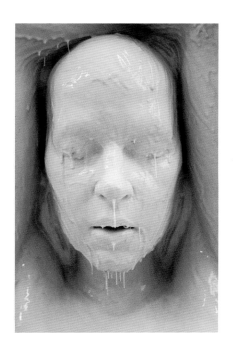
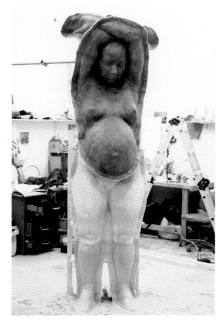
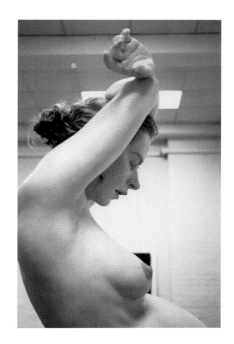

The Swaddled Baby

A tiny baby, wrapped in swaddling clothes and placed on a white pillow, completes the work made in the National Gallery. This new piece is a further exploration of a subject Mueck has addressed before, with his big Babies of 1998, and his time at the National Gallery has encouraged him to focus even further on the theme.

While still working on the *Pregnant Woman*, Mueck saw images of swaddled babies from the Far East that triggered his interest and helped him decide to make a sculpture of the subject. Swaddling a newborn child is now unusual in the West but remains common practice in Central and Eastern Europe, and even more so in the Far East. A child is swaddled for the first few weeks of its life to constrict its limbs while it becomes used to its new environment outside the containment of the womb. The swaddling clothes are intended to replicate the sense of restriction suddenly and violently lost at birth.

A chance sighting in London's Charing Cross Road of a Romanian beggar

sitting with a swaddled baby was important to the making of Mueck's piece. At first he did not realise that the tiny package the woman held was a child. He watched her as she moved it from hand to hand; in the artist's own words 'like a loaf of bread'. The infant could not have been more than three weeks old. Tightly wrapped, with only its face showing, it looked impossibly miniature, as if it was altering its own scale in a parody of Mueck's characteristic shrinkages. Mueck was accordingly inspired to make his *Swaddled Baby* life-size, the first piece he has made without altering the scale. Paradoxically, however, the baby's tiny size makes it look as if it has indeed been miniaturised.

When considering Mueck's *Swaddled Baby*, it is inevitable that the infant Christ, the most famous swaddled baby in history, will come to mind, in much the same way as Mueck's *Mother and Child* draws inescapable comparison with traditional images of the Virgin and Child. In the National Gallery's collection there is a painting of the *Adoration of the Shepherds* by an anonymous

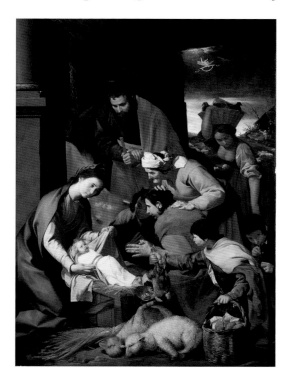

Neapolitan artist in which the Christ Child is tightly swaddled. This picture reinforces Mueck's apt, but unconscious, bread simile, since the basket of loaves on the right of the picture is a symbol to remind the faithful that at the Eucharist the communion bread becomes the body of Christ.

Mueck began making the *Swaddled Baby* immediately after completing the *Pregnant Woman*. He originally planned to make four babies, which were to be displayed together hanging in a row on the wall. After completing all four, this idea was

Neapolitan artist, probably 1630s
The Adoration of the Shepherds
Oil on canvas
228 × 164.5 cm
The National Gallery, London

dropped. The decision to show just one came after Mueck had also considered and rejected showing two or three together. If he showed more than one, he felt, the piece would simply become an exercise in comparison for viewers, who would surely be tempted to merely try and spot slight differences between each face – certainly not what the artist intended. The others have not been abandoned, but put aside for later consideration as works in their own right.

As there was no reason to produce realistic bodies for these babies, only the heads were moulded in clay and cast out in silicone. The body that Mueck makes us imagine, snug inside the swaddling, is simply polyurethane foam filling that has been wrapped and bound. However, the little wisp of hair that shows from underneath the cotton headpiece of the *Swaddled Baby* successfully emphasises the frailty of that body we do not see, concealed and constricted beneath the swaddling. The material for the swaddling was chosen after Mueck had experimented with a variety of coloured fabrics and types of binding.

Mueck has consistently emphasised that the four new pieces he has made for this exhibition should not solely be interpreted in terms of birth and motherhood. Of the works he has produced at the National Gallery, this last piece perhaps makes his point most powerfully: that he sees the four pieces as being about containment. The baby from or in the womb, the man in the boat and the bound-up infant all share some sense of restriction. The white cotton

around the head of the *Swaddled Baby*, combined with the dull brown of the body wrapping, gives the sculpture a monk-like appearance which is reinforced by the string that ties up the whole package. This hint of a monk's solitary, contemplative life, shut away in the confinement of a monastery, adds another aspect to this little figure.

It is possible to return to the element of self-portraiture in Mueck's work in the context of this piece. Mueck's sudden high profile in the art world was unlooked for, and has taken him by surprise. He was unprepared for the amount of media coverage, particularly the myriad requests for interviews following his inclusion in the *Sensation* exhibition. He would much prefer to be left alone to work in privacy without having to make himself and his private thoughts public. The *Swaddled Baby* is fast asleep and inhabits a world that exists only in its own head. It seems as safe and as cosy as it did in the womb, although in reality its birth has given it a fragility and a vulnerability of which it is, as yet, blissfully unaware. It was, perhaps, predictable that Mueck should decide finally upon one solitary baby, given the dominance of single figures in his career so far, and the solitary way in which he works. If the *Man in a Boat* can be understood as a metaphorical self-portrait, so, too, can the *Swaddled Baby*.

It is tempting to think of the four National Gallery pieces as having some kind of narrative logic that unites them and enables us to see them as a

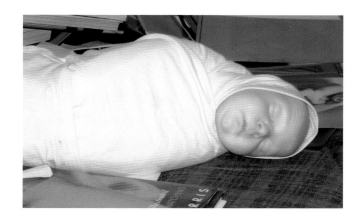 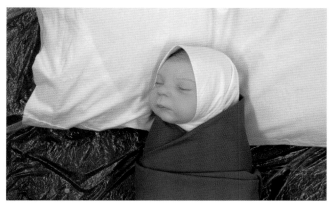

whole. Starting with *Pregnant Woman*, we inevitably move to *Mother and Child*, then on to the *Swaddled Baby* and finally to the *Man in a Boat*, even though the four pieces were not made in that order. The sculptures function both as individual works, and in relation to one another.

They can also be seen in the context of the other work made in Mueck's National Gallery studio, before he embarked deliberately on the pieces for this exhibition. Initially, he worked as if he was not in the Gallery, realising only later that the wall-mounted *Baby* owed its origin to the fact that he was surrounded by Old Master paintings, working among so many odd-looking babies. Mueck's conscious involvement with the Gallery's collection after his invitation began with *Mother and Child*, made over a year after he moved in. The pieces produced during the first year in the National Gallery, however, hint at those same themes that was to explore specifically for this exhibition. The *Old Woman in Bed*, contained within her bedclothes, is arriving at the end of the journey started by the newborn infant of *Mother and Child*, and is wrapped up in a way that presages the *Swaddled Baby*. The *Big Man*, gruffly enclosed within himself, and the *Man in Blankets*, curled up in his foetal posture, all happily fit within the theme of containment that so interests Mueck.

Colin Wiggins

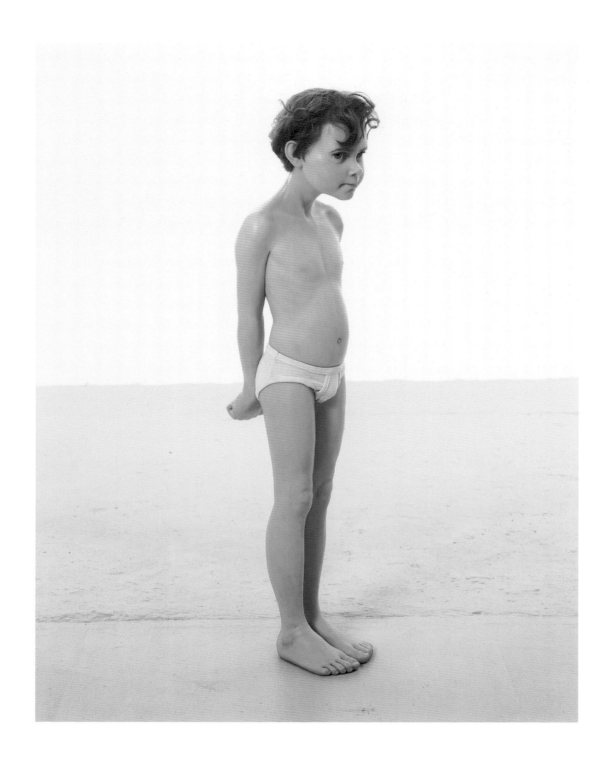

Pinocchio, 1996
Mixed media
84 × 20 × 18 cm
The Saatchi Collection, London

Ron Mueck: A Redefinition of Realism

Visitors to the Hayward Gallery's *Spellbound* exhibition in 1996 were surprised to find the small figure of a young boy, naked but for a pair of white Y-fronts and a mischievous expression, standing in a room full of Paula Rego's giant canvases. Nothing in the gallery explained his presence, but the curious could find the story among the press clippings pinned up outside. Rego had asked her son-in-law, model-maker Ron Mueck, to sit for her painting of Gepetto as he made his own Pinocchio. Mueck created not a puppet but a very real boy, who slipped unannounced into the art world under Rego's skirts. The fairytale parallel is beguiling. Gepetto, the master-craftsman, put aside his everyday work to pour all his skill into a figure made to fill a gap in his life. Mueck had enjoyed a successful career making models for film, television and advertising but, feeling increasingly unfulfilled and frustrated by working to order, he had begun making work for his own private satisfaction. Mueck's *Pinocchio* was also to change its maker's life after a fashion, turning him into a creator of 'living' sculpture. Enter the familiar character of Charles Saatchi, fairy godfather to the YBAs: intrigued by *Pinocchio*, he sought Mueck out, eventually acquiring his giant Babies, *Angel* and *Dead Dad*. This last became Mueck's first officially exhibited work, in *Sensation* at the Royal Academy (1997), where it stole the show and catapulted Mueck into the first rank of the contemporary art world. Now this exhibition is a chance to look back at the artist's work to date, and an opportunity to consider it – albeit glancingly – in the light of other efforts through history to render the lifelike human figure.

Mueck has created the most flawlessly hyper-real figures in art history, so effectively imitating nature that the categories of art, image and reality seem to be suspended. In the presence of a Mueck sculpture we are astonished by the perfection of the illusion: leaning in, it is impossible to fault, however close your range. Hairs sprout from pores, eyes glisten with moisture, flesh appears flushed or mottled. New developments in the history of art are often represented as

technological advances driven by the pursuit of increased naturalism. Yet this impulse has been constantly checked by a deeply ingrained aversion to the too-lifelike, an uneasiness still present in our response to Mueck's work today. Historically, sculpture has been prized and denigrated for the same qualities – its directness, its power to move and to inspire empathy. The history of sculpture in Western civilisation, then, is also the history of a debate over the very definitions and parameters of the terms 'naturalism' and 'realism'. The pursuit of these qualities has produced the idealised bodies of the high Classical period, when physical beauty was invested with moral or divine qualities, as well as the agonised, suffering body that Medieval sculpture made an arena for Christian doctrine. 'Realism' can be a truth to essential, universal nature or to a detailed observation of particular reality; an encapsulation of beauty or a repudiation of it. Mueck's hyper-realism is not 'simply' the flawless technical imitation of reality, but requires another definition.

Verisimilitude: technique and taboo

Confronting a work by Ron Mueck is an uncanny experience (and locking up a dark gallery full of them, alone, a downright eerie one). It is not that we actually think that they are alive, however, and there is not the momentary jolt of confusion that a sideways glimpse of a life-size dummy can deliver. Our experience of Mueck's illusion of life is more rewarding and prolonged because we are willing participants in the deception. In fact, our amazement is predicated on our awareness of deceit, and our pleasure lies in finding it out. We relish the contradictory messages of eyes and brain, the questioning of our senses. The overwhelming desire to touch that all viewers seem to feel is an urge to corroborate their eyes' impression of living warmth and softness. We indulge the fancy that as we turn away a feathered wing might stir, a held breath be released or an eyelid flicker, and we feel a genuine shiver of the uncanny. Despite our intellectual understanding of their man-made status,

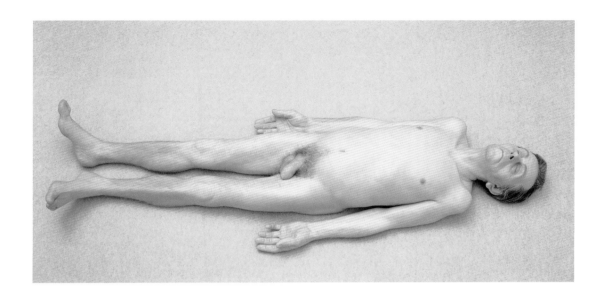

tension arises from the conflict between the material's inertia and its impression of liveliness; the fear of the lifelike which haunts the warring perceptions of the image as reflection, and the image as reality.

What lies behind the lifelike human figure's power to fascinate and to unsettle us? Another fairytale in which a man combines hands' skill and heart's longing to infuse a work of art with life, the story of Pygmalion and Galatea, is the founding myth of Western sculpture and paradigmatic act of creation. When the legendary King of Cyprus fell in love with the statue of a beautiful woman he had made, Venus brought her to life. The story describes the magical process through which a three-dimensional sculpted form can 'become' a living, breathing entity. Similar tales are found in other mythologies, and stories of men's desire to create a living creature appear in many guises; among them the Jewish tradition of the golem, Descartes' automaton Francine and Frankenstein's monster. Each is an allegory of the rewards and risks inherent in the creative act — and more particularly an expression of our awareness that by creating a human figure we parody the act of divine creation. The taboo that prohibits representation from approaching life too closely is deeply ingrained.

Dead Dad, 1996–7
Mixed media
20 × 102 × 38 cm
The Saatchi Collection, London

Western traditions of aesthetics and philosophy are founded on Platonic theory, which deems exact representation both impossible and undesirable, and we are conditioned by centuries of polemic and prohibitions surrounding images.

The Pygmalion myth acknowledges the power of human responses to art, specifically to the three-dimensional human form. We well know that people are aroused by sculptures, pray and make pilgrimages to them, smash and topple them, are calmed or incited to revolt by them. The democracy and directness of sculpture's appeal, the strange seductive magnetism of its 'thingness', has been the cause of intellectual suspicion and distaste, and has resulted in the negative value sometimes placed on verisimilitude. Baudelaire identified a popular preference for sculpture's 'unrefined immediacy' in an essay with the uncompromising title 'Why Sculpture is Tiresome', and his is only one attack in a long historical debate that has largely favoured painting over sculpture.[1]

A related prejudice, again stretching back to antiquity, is the belief in sight's supremacy over the other senses. Touch, the sense which Mueck's rendering of warm, heavy flesh or fine downy hair most arouses, has been deemed unreliable, dangerous, even morally questionable. At the same time, the oldest, clichéd compliment that can be paid to a sculptor is to say that he can make marble seem flesh and blood, or make sculptures breathe or move. Daedalus, mythic progenitor of Greek art, was said to have made sculptures that walked off their bases – hyperbole taken so literally that statues have been excavated chained to their plinths at the ankle. Classical texts are full of admiring anecdotes of artists' ability to deceive – Zeuxis' painted grapes that were pecked by the birds, the calf which pined and starved beside Myron's sculpted cow – as well as statues' power to provoke emotion, and even violence and lust (the Knidian Aphrodite, the most impossibly beautiful representation of woman, was said to have a stain on her flank left by one particularly overwhelmed art lover). Similar formulae resurface in accounts of the master sculptors of the Renaissance, and seem not much more than mannered cliché when they appear

in epigrams saluting Antonio Canova's 'blushing marble'.[2] It is sculpture in particular, of course, occupying our three-dimensional space, which can fool us into responding as if to the real.

Mueck's works render flesh, blood, hair, substance and texture with breath-taking accuracy. What else do we look for to test for signs of life? Movement is perhaps the first signifier. Mueck's sculptures are still, but not frozen mid-gesture: in attitudes of rest, they retain the possibility of motion. We also look to the eyes — which is why it is so disturbing to see an image, or indeed a person, without them. There is a Chinese tradition that the painter does not complete the eyes of his subjects, in order to prevent them escaping his control.[3] Mueck lavishes extraordinary care on hand-making his models' eyes in many stages, building up a transparent lens over a coloured iris and deep, black pupil. When he finally inserts them the effect is startling, as the figure appears to come to life. A waxwork's vacant, glassy stare quickly betrays lifelessness. Not only are Mueck's eyes astonishingly real, but they may glint from half-closed lids, be partly concealed, or cast reflectively downwards: our sense of a life behind the eyes persists.

Dead Dad's eyes are closed. His thick grey hair has been brushed back from the lined face, now slackened into melancholy repose. This is the one sculpture in which Mueck convinces us not of the presence, but of the absence of life. Although we know better, we experience the chilling sensation that we are looking not at a representation but at the thing itself, a corpse. The body is real to us in every fleshy detail, but somehow we know that life — once present — has now departed. *Dead Dad* encapsulates one of the crucial questions at the heart of Mueck's work: what distinguishes animate and inanimate matter; what is the essence that animates, the spark that consititutes life? As Craig Raine has written 'Ron Mueck's sculpture explains why man has felt the need to invent the idea of the soul'.[4]

The Kritian Boy to Mueck's *Boy*

One figure stands at the origin of the history of naturalism in sculpture, a distant ancestor in whatever erratic lineage we might trace to Mueck. Dubbed 'cover boy of the Greek revolution', the Kritian Boy represents the end of a stiff and stylised sculptural tradition and signals the movement towards an accurate imitation of nature, one of Western art's most profound developments.[5] Two key factors in this revolution were technological innovation – the invention of techniques that would allow greater detail – and the drive of narrative, the desire to involve viewers through convincing emotion and drama in order to better tell a story. Here are the basic impulses which have held true down to Mueck: refining techniques to create a closer imitation of reality, and so convey a convincing psychological presence. However, the newly naturalistic figures of the Classical period were athletes, heroes, gods. They represented an ideal, achieved by blending the human and divine, the universal and the specific. These Classical principles were later codified by the Renaissance into

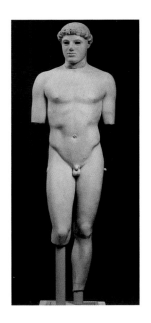

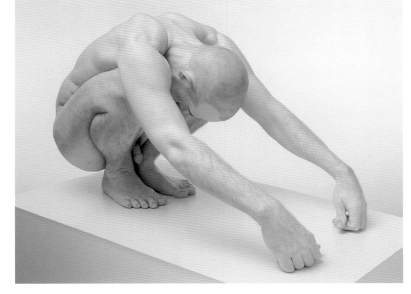

Kritian (or Kritios) Boy,
about 480 BC
Parian marble
About 86 cm high
Acropolis Museum, Athens
(inv. 698)

Man with Shaved Head, 1998
Mixed media
49.5 × 36.7 × 83.8 cm
Private collection

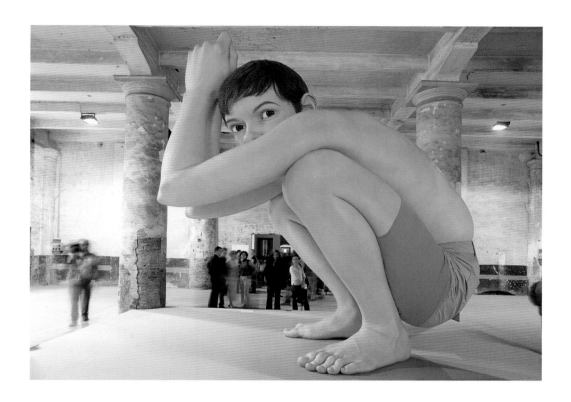

mathematical rules governing proportion and anatomy, perspective and foreshortening, composition and symmetry. One of the most familiar images of the Renaissance, Leonardo da Vinci's (1452–1519) *Vitruvian Man*, perfectly demonstrates their lasting influence on Western aesthetics.

Mueck's work seems so scrupulously faithful to reality in the detail that one does not immediately notice the larger liberties he takes with precisely these principles of proportion and anatomy. Although he uses life models, *Boy*, *Big Man* and *Man with Shaved Head* are all in poses Mueck's sitters found impossible. Their bodies are folded into more compact forms than we can easily achieve, yet each one seems relaxed, absolutely balanced and stable, solidly rooted to the ground. Out of the knot of his body the *Man with Shaved Head* drapes long arms and huge, heavy hands, knuckles weighted to the ground in front of him. Mentally unfolding him to standing height, we can

Boy, 1999
Mixed media
490 cm high
Aarhus Kunstmuseum, Denmark

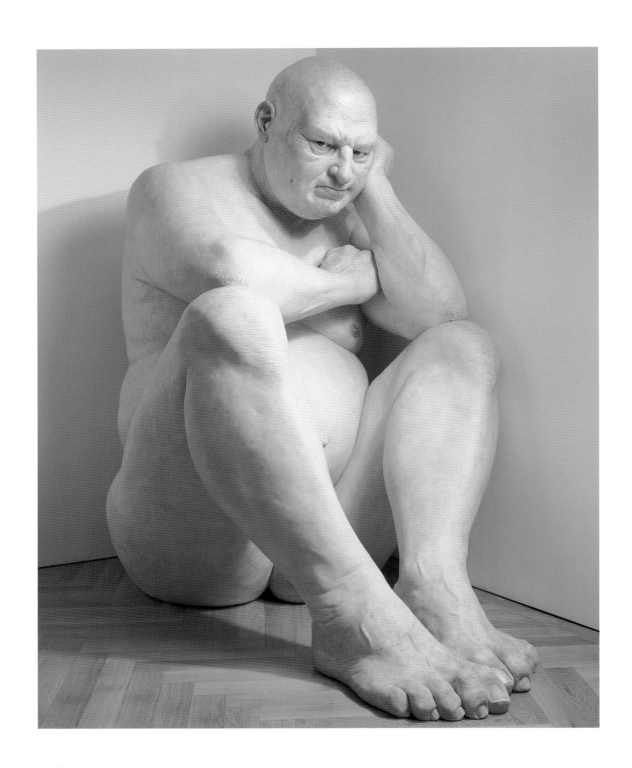

Big Man, 2000
Mixed media
205.7 × 117.4 × 208.8 cm
Hirschhorn Museum and Sculpture Garden, Washington DC
Smithsonian Institution

Joseph H. Hirschhorn Bequest Fund, 2001

imagine how disproportionate they would seem
to his frame (here is an echo of Michelangelo's
David, enormous hand resting gracefully against
his thigh). He has the latent energy and grace of
an athlete, seeming simultaneously coiled and at
rest, his furled body balanced against the droop
of his arms. *Big Man's* dense, solid bulk is packed
into a corner, a fleshy manifestation of brooding
misery. Perversely, these expressive distortions
invest Mueck's figures with the living charge that
an actual life-cast lacks: though it may be a
perfect and exact reproduction of a living body,
a cast will always seem a stiff, dead shell. Mueck
works from life, from found images and
anatomical source books, but he does not apply
any methods of calculation. His sculptures can

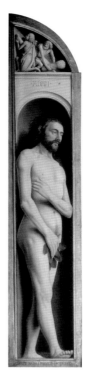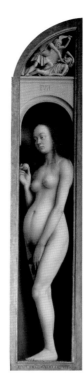

spend weeks and months as clay while he gropes towards a sense of proportional
'rightness' for the figure that is not based on fidelity to a living model, but is
particular to the figure he is creating.

Mueck's figures are also far from perfect or ideal: they are awkward,
flawed, mortal flesh. His reality has the shocking honesty of the Gothic, an
unflinching observation of the body naked, rather than nude. Certainly Jan
Van Eyck's *Adam* and *Eve* appear stark naked. These are real people, minutely
observed and reproduced with dispassionate accuracy. There is none of the
idealising influence of classical Greece which Van Eyck's Italian contempo-
raries never quite lost. Van Eyck was a technical innovator, developing the new
medium of oil glaze to reproduce reality in finer, more glowing detail. His array
of visual effects of texture and surface is dazzling: wisps of hair, stiff brocade,
hand-blown glass and polished pewter are rendered with an almost unnatural
clarity. This is a reality constructed through the build-up of crystalline

Jan Van Eyck
(active 1422; died 1441)
Adam and Eve, 1432
Oil on wood
Altarpiece 350 × 223 cm
when closed
St. Baafskathedraal, Ghent

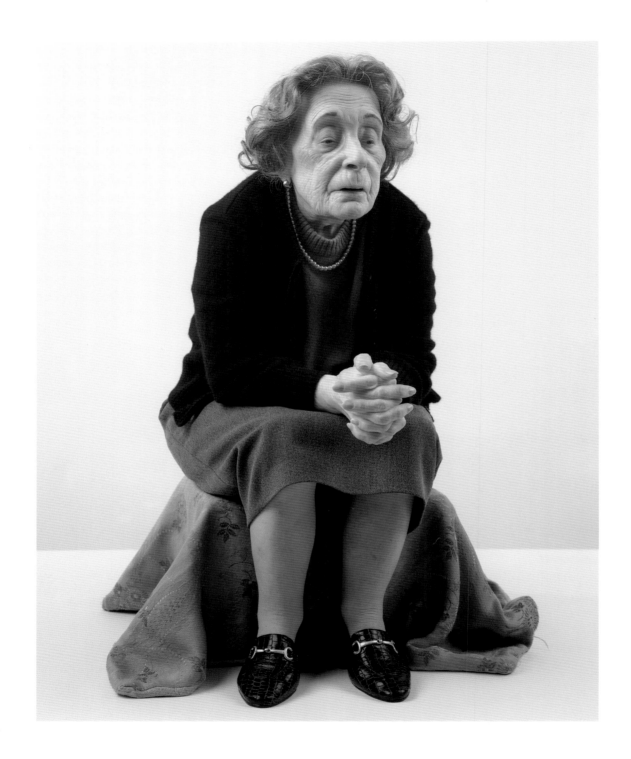

Seated Woman, 2000
Mixed media
59.6 × 43.8 × 47 cm
Modern Art Museum of Fort Worth

observed detail rather than a masterly adherence to the many scientific laws of the Renaissance. In the same manner Mueck assembles an exhaustive itemisation of the body, from a calloused heel to a ridged fingernail or the shadowed hollow of a throat. There is a shared sensibility in Mueck's figures and in the hard, brilliant clarity of the Northern revolution in realism. Compare his *Seated Woman* with Albrecht Dürer's portrait of his father at seventy (in the National Gallery) or *Dead Dad* with Hans Holbein's devastating image of *The Body of the Dead Christ in the Tomb*, glassy eyed, his hand a stiff claw.

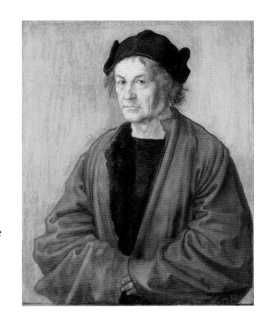

A neat binary system was established during the Renaissance, Gothic North on the one hand and Graeco-Roman South on the other, excluding the Iberian Peninsula altogether. But the art which flourished there from the fifteenth century onwards, ignored or dismissed by the rest of Europe, positively embraced the unsettling power of the hyper-real. The Spanish polychrome tradition saw painters and sculptors collaborating to produce figures of extreme naturalism, carved in wood before being coated in gesso, smoothed and painted, and finished with glass eyes, ivory teeth, real hair, clothing and jewels. Gregorio Fernandez, the seventeenth-century master of the Valladolid school, muted the gaudy colours and restrained the exaggerated gesture of his predecessors. His *Ecce Homo* simply asks the viewer to behold Christ as man, confronting us with a life-size figure, seemingly of flesh and blood. The apogee of the tradition is represented by the refined and sensitive modelling and meticulously accurate detail of Fernandez and his near contemporary Juan Martinez Montañes (about 1568–1649). Their technique of painting the flesh was perfected to convey

Attributed to Albrecht Dürer (1471–1528)
The Painter's Father, 1497
Oil on linen
51 × 40.3 cm
The National Gallery, London

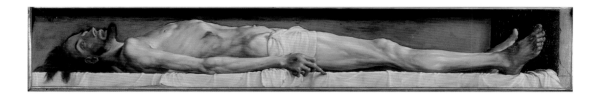

palpitating veins and muscles tense or slack beneath the skin, detailing every minute accident of surface and substance. The intention was to create figures with the greatest possible physical, sensual presence, of the most convincing reality, as if actors within a narrative drama. The Virgin, for example, was more likely to be portrayed as a distraught middle-aged woman than a classical Venus with child. By deliberately breaking down the borders between art and reality and so the separation of the figure from the viewer, they meant to communicate, emotionally and viscerally, a religious message. Rejecting idealised aesthetics, their aim was to embody real human emotion and suffering, and the artist's success was measured in the tears and ecstasies of the viewer. The effect was intended not only for the simple and credulous; patrons and connoisseurs wrote admiringly of being hypnotised, transported or overwhelmed.

The pitch of emotion and religious fervour may seem very foreign, but the shocking reality and directness of these sculptures bear an obvious relation to Mueck's work. The Spanish sculptors use our connection with their 'real' people to suggest universal (religious) truths. Mueck's figures are intensely personal, particular representations but they seem to function in the same way, connecting us to universal emotions and experiences. The experience of this lapse between the reality of the art object and reality itself demands a response that integrates emotion and cognition. That is to say, Mueck's works commonly provoke a response to the subject itself, the person represented, and elicit memories of our own emotions and experiences, mundane and profound: childhood, childbirth and parenthood, the ageing and death of a parent. It is not a form of response which the contemporary language of formalist criticism is equipped to deal with, though it is as valid to our understanding of Mueck's

Hans Holbein the Younger (1497/8–1543)
The Dead Christ in his Tomb, 1521
Varnished tempera on panel
30.5 × 200 cm
Öffentliche Kunstsammlung, Basel (inv. 318)

works as any informed perception of art historical resonances. Sculpture that imitates reality has historically been suspect on the grounds that it is likely to provoke a baser response, working on an emotional or physical level rather than a refined intellectual one. It is a distinction that sometimes still seems to be operating, as betrayed by a critical suspicion of work with popular, accessible appeal.

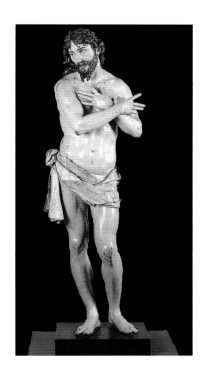

The perceived distinction between 'high' and 'low' became increasingly exaggerated in the eighteenth century. The craze for excavating, studying and collecting Classical sculpture grew, the dazzling whiteness of its unearthed state enforcing its status as the sublime, philosophically pure ideal. At the same time, dolls, dummies, automata and wax works were increasingly popular entertainments, so that all lifelike treatments of the body became associated with these 'low' or 'debased' forms. However, by the end of the century the increasing weight of evidence finally forced a major reassessment of the antique.[6] Rather than being the model and embodiment of eighteenth-century moralised aesthetics, it was discovered that Greek sculpture had been brightly painted and ornamented, with wire eyelashes and tinted lips and nipples. Now we know that even the Kritian Boy had once had inlaid eyes, and probably — like the Parthenon — an organic wash toning down the bare marble. Ironically, having provided the inspiration for the pure marble body of Neoclassicism, the ancient world was to provoke the nineteenth century into a range of experiments in painted, tinted and mixed-media sculpture.

Nevertheless, when Edgar Degas first exhibited his *Little Dancer of Fourteen Years* in 1881, his contemporary audience found the work deeply

Gregorio Fernández (1576–1636)
Ecce Homo, 1617
Polychrome wood
168 cm high
Museo Diocesano-Catedralico, Valladolid

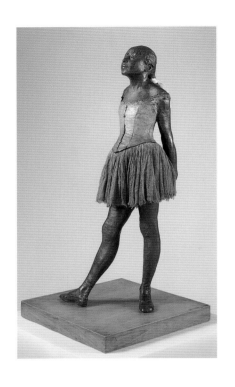

shocking. Modelled in wax and tinted rosily, she was dressed in a fabric tutu and bodice, stockings and slippers, with a wig of real hair tied back in a green ribbon (the bronze casts we are now familiar with were not made until 1921). These materials associated her with carnival and the grotesque, with scientific study, and with the newly rediscovered Spanish Catholic tradition, while her brutish features and assumed immorality horrified contemporary viewers. One observed that she 'belonged in a zoological, anthropological or medical museum'. The critic J. K. Huysmans diagnosed his own sense of revulsion: 'the terrible reality of this statuette makes one distinctly uneasy; all one's ideas about sculpture, about these inanimate whitenesses, about these memorable clichés copied down the centuries, all are overturned.' His final verdict was that this was 'the first truly modern sculpture'.[7] Rather than an attempt to portray an ideal or generalised humanity, she is, like Mueck's figures, a very particular, individual and unromanticised type, her personality proclaimed by the pert jut of her chin.

In common with the *Little Dancer* and the Spanish saints, Mueck's figures have real clothes and hair. In fact, *Dead Dad*'s legs are prickled with the artist's own hair (a practice which he has not been able to sustain for obvious reasons). Though entirely practical, this detail lends the work a powerful aura of reliquary or votive representations of the dead. Since Mueck is extremely sparing in his choice of garments or props, each seems rich with significance. Some are invented and made to scale, but often they are found and bear signs of wear and use. The cocoon surrounding *Man in Blankets* is of clean but worn

Edgar Degas (1834–1917)
Little Dancer of Fourteen Years
(1880–1, cast about 1922)
Painted bronze with muslin and silk
98.4 × 41.9 × 36.5 cm
Tate, London (inv. NG 6076)

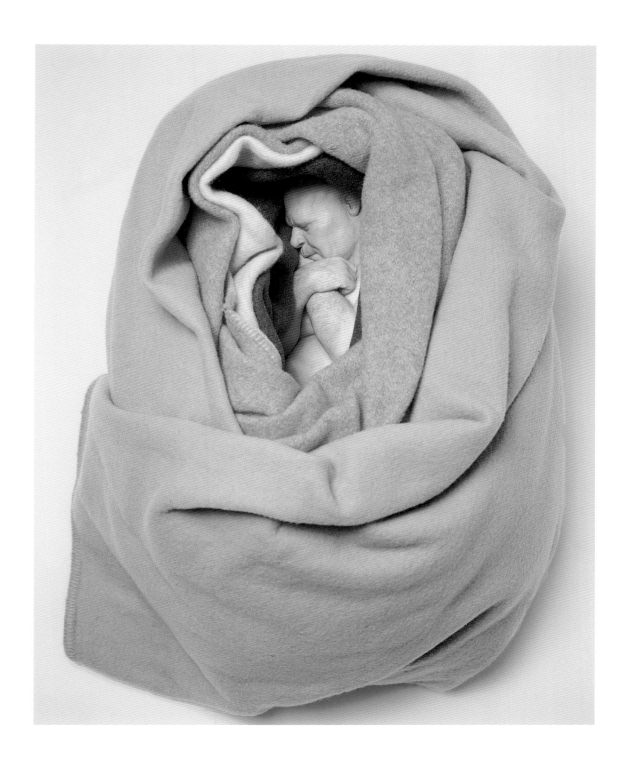

Man in Blankets, 2000
Mixed media
43.1 × 59.7 × 71.2 cm
Private collection

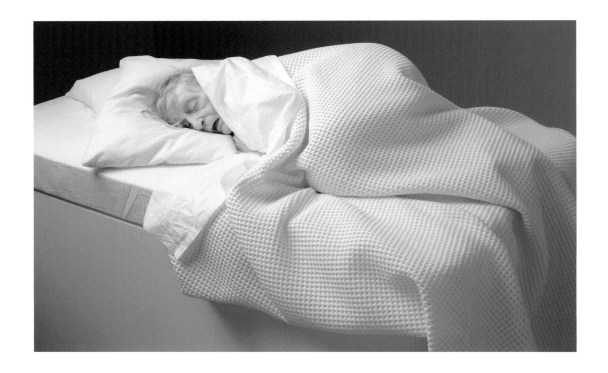

institutional woollen blankets, their charcoal grey shadowing the depths of his nest, the blue and pink of the outer layers picking out his faint flush and blueish veins. Some props are mysterious details, potential clues to a narrative not spelled out to us — but others have immediate clear resonances. *Old Woman in Bed* is folded between crisp sheets that clearly signify a hospital or nursing home. *Seated Woman* has a new woollen twinset and pearls, but the gold-buckled, crocodile shoes bulging over painful corns and her neat gold earrings, Mueck made for her. She sits on a worn and faded piece of brocade which manages to conjure an environment of overstuffed sofas and tables crowded with knick-knacks, and perhaps future generations who will be reminded of her by this piece of cloth.

Old Women in Bed, 2000
Mixed media
24.4 × 94 × 53.9 cm
Anthony d'Offay, London

A new kind of Realism

Realism today often means real objects, or a concentration on real and verifiable concrete qualities, as in minimalism: that is, an existentialist realism rather than an illusionist, counterfeit realism. Even the hyper-real descriptive art of the last few decades is driven by impersonal observation and an unsparing factuality. But Mueck does not merely create the most flawless illusion of reality yet achieved: he restores subjectivity and humanism to the hyper-real. In his minute, unflinching itemisation of real, imperfect human bodies Mueck also manages to convey an internal narrative, in a powerful evocation of what we might term psychological realism. Psychology is, after all, the essential new informant of our contemporary readings, replacing political, mythical or religious constructs. These sculptures are portraits of emotional states, and after our initial astonishment at their verisimilitude it is their impression of an inner life that holds our continued attention. *Ghost* is the embodiment of teenage selfconsciousness, the projection of a stage at which our bodies become suddenly large and strange and acutely embarrassing to us. Two metres tall, rawboned, slightly pimply, she hunches against the wall as if wishing her regulation swim-suit could conceal her. *Seated Woman* is a portrait of ageing, the precise pitch of life-weariness studied as finely as the varicose veins under thick tights or the web of lines netting swollen knuckles. She looks resigned, but not defeated, as she holds her head cocked slightly against the droop of her eyelids and neck.

Scale is one of the most powerful tools Mueck employs with this psychological intent. Though they appear to be made of the same living stuff as us, his scuptures are not of our world. Not human size, though certainly not giants or midgets, they are removed to their own dimension by differences of scale. There are clear historical associations attached to extremes of size in sculpture. Small objects are precious, and often for private enjoyment and handling. The monumental is associated with power and status, spiritual or temporal, and so also with propaganda. Mueck subverts these associations

completely in his distortions of scale, and instead employs it as another means of intensifying the emotional states his figures embody. His colossus, whose size would be appropriate to a temple or city square, is a young, crouching, barefoot boy. These shifts in scale are also a means to force the viewer into a fresh way of seeing. We have to re-focus, as if looking through a lens, as the scale isolates the figure from its surroundings and concentrates our gaze. At the same time we are made freshly aware of the space our own body occupies, measuring ourselves against what we see. *Big Man*'s threatening bulk is obviously magnified still further by his scale, but as he hunkers in the corner we stand taller than him and he appears to retreat from us in his introspective unhappiness. Moving from figure to figure, our sense of our physical selves lurches from feeling clumsy to insubstantial.

Making figures smaller than life-size seems to concentrate and intensify their presence: a tiny baby can dominate an entire wall of a gallery. In *Old Woman in Bed*, Mueck addresses the moment before that we see in *Dead Dad*, in which her breath still seems to labour through her half-open mouth. She is a vulnerable figure, shrinking as her life ebbs, yet her head is the still, compelling focal point of the white bed and larger white space which surround her. Mueck has been much quoted as saying that *Dead Dad*'s size is such that one could pick him up and cradle him. In fact this seems very far from the impulse we actually feel in front of the work, despite our overwhelming empathy. Although we can see every detail in magnified clarity, the small figure seems permanently distant, dwindling. The sculpture is a farewell and a laying to rest. It was inspired not by Mueck seeing his dead father, but by not seeing him: he died less than peacefully on the other side of the world after a painful illness. Mueck describes him as a morose and difficult man who loomed large in his son's life. In death, the artist lays him out, scrubbed, small, silent, peaceful – and beside enormous tenderness there is a sense that Mueck is taking back control, containing and neutralising the realities of his father's life and death.

This is one of the more obvious examples of the intensely personal nature

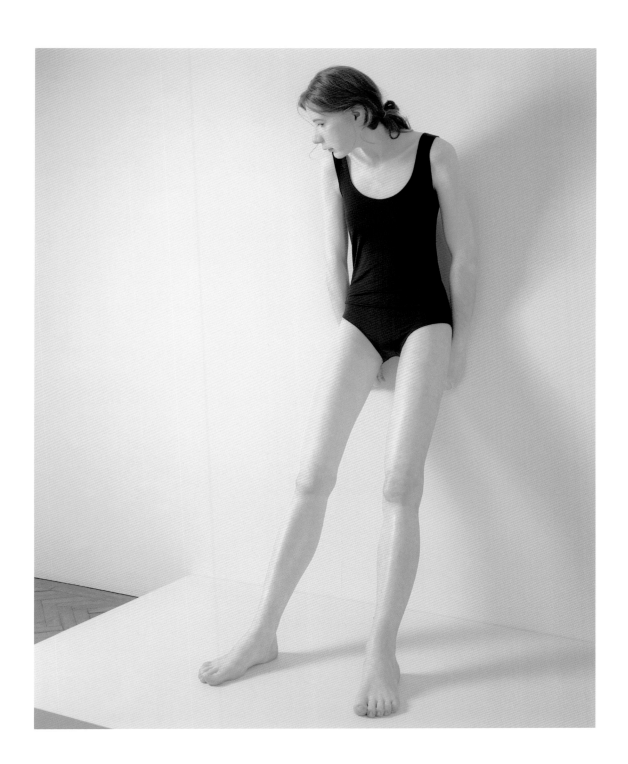

Ghost, 1998
Mixed media
202 cm high
Tate, Liverpool (inv. TO 7445)

of Mueck's work. As well as his father, he has portrayed his wife's grandmother in her final illness, and drawn on his experiences of his children's births. *Mask*, his first self portrait, was inspired by his imagining how his small daughters saw him as he scolded them, his scowling face looming above. In a way, each one of the artist's works contains an element of self-portraiture – quite literally, as Mueck will often use himself as a convenient reference, stripping off a sock while finishing the detail on a foot for example – but also in that these portraits of emotional states are acts of exposure by an intensely private and reclusive artist. His figures seem trapped in various forms of vulnerability, introversion or depression, and appear to resent our scrutiny. Crouching, huddled, in a foetal position or concealing themselves under wraps, they evade our gaze so that we stoop and peer and pry to meet their eyes, then feel ashamed of the intrusion. Mueck's gaze, however, is unflinchingly turned on every imperfection of his subjects and himself. Astonishing accuracy of detail accompanies expressive distortions and inventions, as we have seen, so that what Mueck creates is not a blank imitation but an invocation of reality, summoned out of this minute perfectionism. Its distilled and concentrated essence fits in a very literal way Bernard Berenson's definition of art as 'life with a higher coefficient of reality'. Though infinitely painstaking and laborious, his absolute technical mastery is such that the technique disappears altogether, leaving us with the fact of the body itself. 'His art conceals its art', as Ovid says of his *Pygmalion*.

Susanna Greeves

1. Baudelaire's address to the Academie Francaise Salon of 1846: Joseph Mashek, 'Verist Sculpture' in *Art in America*, vol. 60 no. 6 1972, in *Super Realism, A Critical Anthology*, ed. Gregory Battcock, New York 1975

2. Ernst Kris and Otto Kurz, *Legend Myth and Magic in the Image of the Artist*, New Haven 1979

3. David Freedberg, *The Power of Images: studies in the history and theory of response*, Chicago 1989

4. Craig Raine, *Modern Painters* Autumn 1998, pp.20–3

5. Nigel Spivey, *Understanding Greek Sculpture: ancient meanings, modern readings*, New York 1996

6. Specifically Quatremere de Quincy's findings of his 1815 treatise on polychromy in ancient sculpture

7. Cited in Wolfgang Drost 'Colour, Sculpture, Mimesis; a Nineteenth-Century Debate' in *The Colour of Sculpture 1840–1910*, ed. Andreas Bluhm, Zwolle 1996

Mother and Child

Man in a Boat

Pregnant Woman

Swaddled Baby

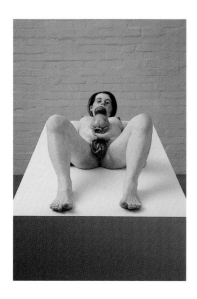

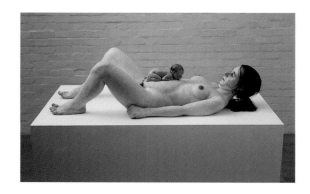

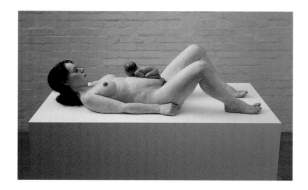

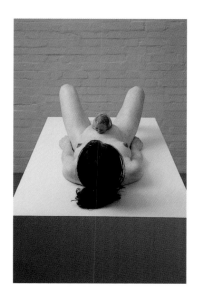

Mother and Child, 2002
Mixed media
24 × 89 × 38 cm
Private collection.
Courtesy of James Cohan, New York

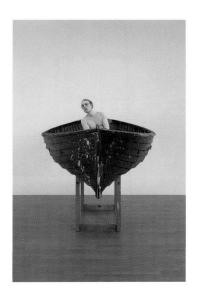

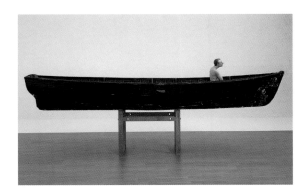

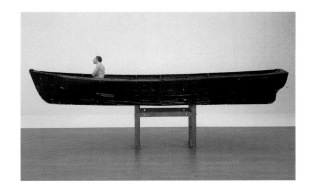

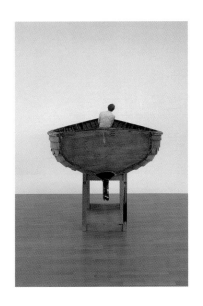

Man in a Boat, 2002
Mixed media
Figure 75 cm high
Boat 427 cm long
Courtesy of Anthony d'Offay, London

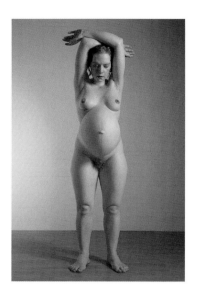

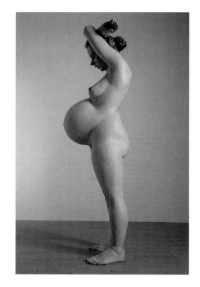

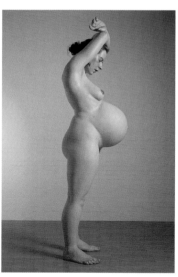

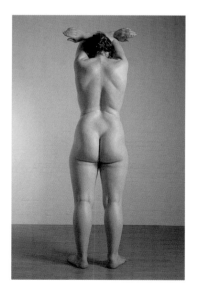

Pregnant Woman, 2002
Mixed media
252 cm high
Courtesy of Anthony d'Offay, London

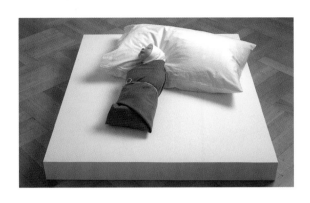

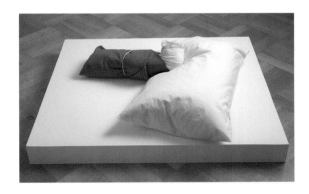

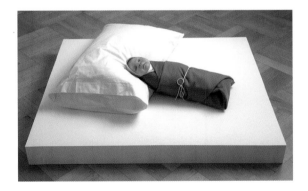

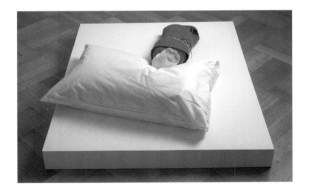

Swaddled Baby, 2002
Mixed media
Figure 54 cm long
Courtesy of Anthony d'Offay, London

Ron Mueck Biography

Born Melbourne, Australia, 1958.
Formal art education ended at high school.
Worked in children's television, motion picture
special effects and advertising for twenty years in
Australia and Great Britain.
Currently lives and works in London.

Solo exhibitions

2002
Hirschhorn Museum and
Sculpture Garden, Washington DC
2001
James Cohan Gallery, New York
2000
Anthony d'Offay Gallery, London
1998
Anthony d'Offay Gallery, London

Group exhibitions

2001
Venice Biennale, Corderie
2000
Ant Noises, Saatchi Gallery, London
Crusaid, Vinopolis, London
The Mind Zone, Millennium Dome, London
1999
Unsichere Grenzen, Kunsthalle zu Kiel
*Spaced Out: Late 1990s Works from the Vicki
and Kent Logan Collection*, The California College
of Arts and Crafts, San Francisco
House of Sculpture, Modern Art Museum
of Fort Worth
Heaven, Tate, Liverpool
1997
*Sensation: Young British Artists from the Saatchi
Collection*, Royal Academy of Arts, London;
Hamburger Bahnhof, Berlin;
Brooklyn Museum of Art, New York
1996
Spellbound, Hayward Gallery, London
(exhibited as part of Paula Rego installation)

Catalogues

Boy, photographs by Gautier Deblonde,
London 2001
Ant Noises, Saatchi Gallery, London 2000
Unsichere Grenzen, Kunsthalle zu Kiel, Kiel 1999
Spaced Out: *Late 1990s Works from the Vicki and Kent
Logan Collection*, The California College of
Arts and Crafts, San Francisco 1999
*Sensation: Young British Artists from the Saatchi
Collection*, Royal Academy of Arts, London 1997

The artist wishes to thank Tony Wood, Cas
Willing, Daniel Scott, Zara Chandler, Kevin
Rowley, Joshua Weston, Jacobson Chemicals Ltd
and Sam Plagerson

Picture credits

Unless otherwise stated:

All works by Ron Mueck are copyright of the artist,
courtesy of Anthony d'Offay, London.

All work-in-progress photography is copyright of the artist,
courtesy of Anthony d'Offay, London.

Pages 10–17 and 64–67
Photos: Mike Bruce

All video stills and reproductions of works in the
National Gallery are © The National Gallery, 2003

Other pictures

Aarhus Kunstmuseum, Denmark (picture Venice 2001)
Photo: Thorsten Arendt / artdoc.de

Acropolis Museum, Athens
© Hellenic Ministery of Culture/TAP, Athens

Kunstmuseum, Basel
© Öffentliche Kunstsammlung, Basel
Photo: Martin Bühler

St. Baafskathedraal, Ghent
© St. Baafskathedraal, Ghent
Photo: Paul M.R. Maeyaert

Tate, London
© Tate 2003

Museo Diocesano-Catedralico, Valladolid
© Museo Diocesano-Catedralico, Valladolid

Reprinted 2003
First published in Great Britain in 2003 by
National Gallery Company Limited
St Vincent House
30 Orange Street
London WC2H 7HH
www.nationalgallery.co.uk

ISBN 1 85709 167 1
525321

British Library Cataloguing-in-Publication Data
A catalogue record is available from the British Library
Library of Congress Catalog Card Number 2002112099

Publisher Kate Bell
Editor Tom Windross
Designer Peter B. Willberg
Picture Researchers Xenia Corcoran
and Catharina Tesdorpf
Production Jane Hyne and Penny Gibbons
Editorial Assistance Carmel Cannon

Printed and bound in Hong Kong by Printing Express Ltd.

Cover: Ron Mueck, *Baby* (work in progress), 2000

Measurements give height before width and depth,
where appropriate.